(SIR) PE

⑧ EQUESTI

(PETER).

⑬ ST. GEORGE AND THE DRAGON (1606-10 ⑯⑮ HERO AND LEANDER. 1607.C,

⑯-⑰ ADORATION OF THE MAC

BRANT, IN THE HONE

(1611-14). ⑳ PORTRA

⑤ THE APOSTLE SIMON

N OF SPAIN. 1603C.

IFE, ISABELLA

FROM THE CROSS.

A. 1612.20C.

㉑ THE FAMILY OF JAN BRUEGHEL THE ELDER. 1613-15 ㉓ THE HOLY FAMILY WITH
SAINT ELIZABETH AND SAINT JOHN THE BAPTIST. 1614-15. ㉔ THE FLIGHT
INTO EGYPT. 1614. ㉖ CHRIST'S CHARGE TO PETER. 1614C ㉙ FARMYARD
WITH A FARMER THRESHING, AND A HAY WAGON. 1615C. ㉚ HEAD OF A CHILD.
1616C. ㉛ THE RAPE OF THE DAUGHTERS OF LEUCIPPUS. 1616-19.

㉜-㉝ ST BARBARA FLEEING FROM HER FATHER. 1620. ㉞-㉟ A LION HUNT.

㊱-㊲ ADAM AND EVE IN PARADISE. 1620C ㊳ THE EDUCATION OF DE' MEDICI.
1622-5. ㊵-㊶ (DETAIL FROM) THE ARRIVAL OF MARIA DE' MEDICI AT
MARSEILLES. 1622-5C. ㊷-㊸ THE CORONATION OF MARIA DE' MEDICI. 1622-5C.
㊺ THE TRIUMPH OF JULIERS. 1622-5C. ㊻ LE CHAPEAU DE PAILLE. 1622-5.
㊾ SELF-PORTRAIT. 1624C. ㊽ ISABELLA BRANT, WHOM RUBENS MARRIED
IN 1609. 1625C. ㊾ PORTRAIT OF RUBEN'S SON. 1624C ㊿-51 THE DUKE OF
BUCKINGHAM ESCORTED BY MINERVA AND MERCURY TO THE TEMPLE OF 'VITRUS'.
1625C. 52 ADAM AND EVE. 1628-29. 53 THE UNION OF HENRY IV AND MARIA DE'
MEDICI. 1628-31C. 54 PORTRAIT OF PHILIP IV.
OF THE BANQUETING HOUSE, WHITEHALL. (COMPLE
WITH AN OSTRICH FAN. 1632-5. 58 THE GARDEN C
61 THE KERMESSE. 1635-8. 62 LANDSCAPE WITH A RAINE

64. THE JUDGEMENT OF PARIS. 1635-40.

65. LANDSCAPE BY MOONLIGHT. 1635-40.

66-67. THE RAPE OF THE SABINE WOMEN. 1635c.

68-69. DIANA AND CALLISTO. (AND 69)

69. LANDSCAPE WITH CHÂTEAU DE STEEN. 1635-7.

70. HÉLÈNE FOURMENT AND HER SON FRANS. 1635c.

71. HÉLÈNE FOURMENT AND TWO OF HER CHILDREN. 1635c.

72. A PEASANT DANCE. 1636-40.

73. THE THREE GRACES. 1639.

74-75. LANDSCAPE WITH PHILEMON AND BAUCIS. 1636-40c.

76. THE JUDGEMENT OF PARIS. 1638.

77. SELF-PORTRAIT. 1639.

78. THE BIRTH OF VENUS. 1632-4.

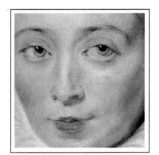

THE LIFE AND WORKS OF

RUBENS

Janice Anderson

A Compilation of Works from the
BRIDGEMAN ART LIBRARY

· PARRAGON ·

Rubens

This edition first published in 1996 by
Parragon Book Service Ltd
Units 13-17 Avonbridge Industrial Estate
Atlantic Road
Avonmouth
Bristol BS11 9QD

ISBN 0 75250 815 6

Printed in Italy

Editors: Barbara Horn, Alexa Stace, Alison Stace, Tucker Slingsby Ltd and
Jennifer Warner.
Designers: Robert Mathias and Helen Mathias
Picture Research: Kathy Lockley

The publishers would like to thank Joanna Hartley at the
Bridgeman Art Library for her invaluable help.

Sir Peter Paul Rubens 1577-1640

Peter Paul Rubens has been called the greatest exponent of Northern Baroque, an extension of the Baroque art of 17th century Italy which influenced, with modifications, much of the art of Catholic Europe (and was not without influence in such Protestant countries as Britain and the Netherlands) until well into the 18th century. Baroque art, at its finest, was a marriage of the arts of architecture, painting and sculpture intended to invite the spectator to take part emotionally in what it was portraying. The style involved a rich and often emotionally overwhelming blend of colour, light and movement. It was a style of work at which Rubens excelled and for which his warm-hearted, emotional and outgoing personality and his cultured European background and Catholic religion were ideally suited.

Peter Paul Rubens was born at Siegen in Westphalia, of Flemish parents, on 29 June 1577. The Rubens family were in Westphalia because Jan Rubens, Peter's father, had been forced to flee from Catholic, Spanish-ruled Antwerp under suspicion of being a Calvinist. The family did not return to Antwerp until Jan Rubens died in 1587.

Rubens began studying art in his teens, being a pupil of several Flemish artists, including the knowledgeable and cultured painter, Otto van Veen. It was probably van Veen who advised Rubens to go to Italy to study painting. The young man, already a promising artist, went to Venice in 1600, where Titian's legacy was still paramount. From Venice, Rubens went to Mantua to take up a position as Court Painter to Vincenzo Gonzaga, Duke of Mantua.

His position in the Duke's household gave Rubens every opportunity to travel in Italy, studying painting in Rome, Milan and Genoa. In

1603 the Duke sent him with an embassy to Spain, taking gifts, including paintings, to Philip III. In Madrid, Rubens encountered the work of Titian and Raphael in the royal collections and carried out major commissions for the royal collection and for the Duke of Lerma, the king's first minister.

It was thus a much travelled and artistically experienced young man who returned hurriedly to Antwerp in 1608 to see his dying mother. In the event, Rubens was too late to take farewell of his mother and was planning to return to Italy when he was offered the appointment of Court Painter to the Spanish governors of the Netherlands, the Archduke Albert and Archduchess Isabella, a daughter of Philip II of Spain. When Philip II had appointed Albert and Isabella governors of the Netherlands it had been in the expectation that they would produce a son who would become sole sovereign of the country. In fact, no son was born and when Albert died Isabella became sole Regent of the Spanish Netherlands and a person of great importance in Rubens' life, both as patron and friend.

Rubens was to spend the rest of his life in Antwerp. In 1609, a truce was arranged between Holland and Spain, ensuring a respite from war in the former Spanish possessions north of France. That year Rubens accepted the position of Court Painter, married, built himself a splendid house in Antwerp and settled down to the life of a rich and successful artist. His wife was Isabella Brant, daughter of a well-to-do and cultured Antwerp citizen and Rubens was to know seventeen happy years of marriage with her.

There followed what has been called the most fruitful and energetic career in the history of art. Rubens had a large studio in which he employed many promising artists and he himself followed the custom of the time by working in collaboration with other established artists on numerous projects. Among his chief assistants in his studio were Anthony van Dyck, Jacob Jordaens and Frans Snyders. He produced mythological and religious pictures, portraits and landscapes of considerable power and beauty and in unparalled quantity, and his glori-

ous painting of the female nude has seldom been matched.

His work was on a Europe-wide scale, with commissions from many rulers, including Philip III and Philip IV of Spain, the Queen Mother Marie de' Medici in France, and Charles I in England, to help spread his fame widely. He also became increasingly involved in the diplomacy of his time, being used by the Archduchess Isabella on several delicate missions to Spain, France and England, where he was knighted by Charles I in 1630.

The death of his wife Isabella in 1626 was a great blow to Rubens, to whom a background of domestic felicity was essential to his well-being. A long period in Madrid in 1628-9, on a diplomatic mission which gave him much time for painting, restored his optimism and a second marriage in 1630, to a beautiful girl many years his junior, brought about a second flowering in Ruben's artistic genius.

The last decade of his life, living partly in the country on his new estate of Steen surrounded by the growing family he had with Hélène Fourment, was a period of beautiful landscapes, of paintings of peasant life filled with warmth and happiness, and of a constant stream of warm and intimate drawings, oil sketches and paintings of his wife and children. Towards the end of his life, Rubens was increasingly ill and also stricken with gout, which made painting difficult, so that he had virtually to abandon large-scale works in favour of easel paintings.

Peter Paul Rubens died on 30 May 1640 and was buried in the Church of St James in Antwerp.

▷ **Equestrian Portrait of the Duke of Lerma** 1603

Oil

IN 1603 RUBENS was sent on a mission to Spain by his patron, the Duke of Mantua. His task was to deliver some paintings, including one of his own, to Philip III's first minister, the Duke of Lerma. While in Spain, Rubens was commissioned to do a number of works for inclusion in the royal collection. For the duke himself, Rubens painted this superb equestrian portrait, which both provided a new approach to the painting of equestrian portraits in general and also introduced the genre to Spanish art. Preliminary drawings for the painting exist, showing the care with which Rubens went about planning the portrait.

The final work is both a superbly dignified and richly decorated portrait and a brilliant feat of perspective painting. Rubens uses considerable artistic skill to make the form of the great horse, shown advancing out of the canvas and depicted in an upward-flowing curve of leg, neck and head, focus attention on the figure of the duke.

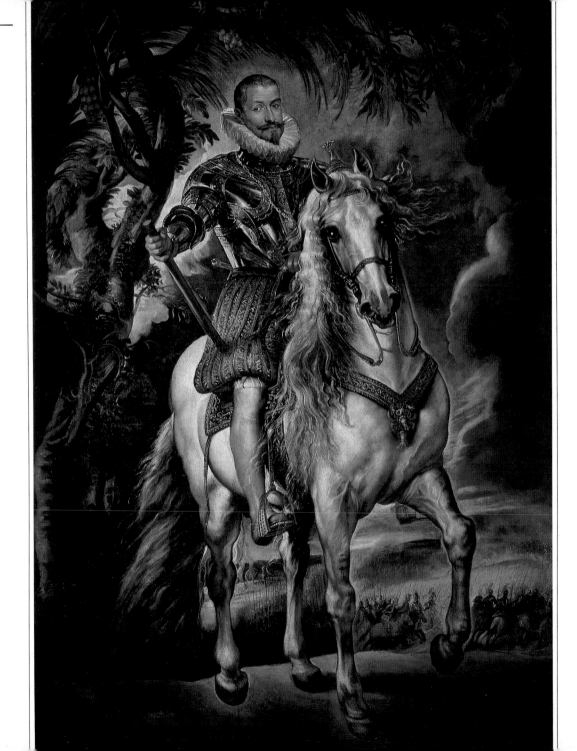

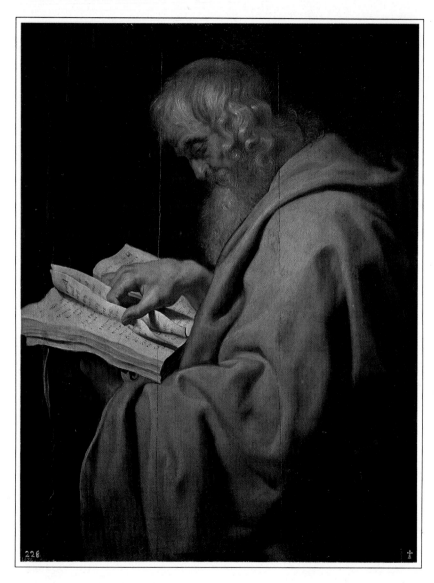

◁ **The Apostle Simon (Peter)**
c.1603

Oil on panel

AN IMPORTANT commission received by Rubens while he was in Spain in 1603 was for a series of 'portraits' of the Twelve Apostles. In great contrast to his portrait of the Duke of Lerma, Rubens portrayed his apostles in simple style, against plain, dark-coloured backgrounds. While the style and approach of the paintings show the influence of the great Italian masters Rubens had been studying in Italy, including Titian and Raphael, the portraits themselves are all vigorously executed, realistic studies of men, not characterless plaster saints such as might be encountered in churches all over Europe.

▷ Portrait of Isabelle de Valois, Queen of Spain c.1603

Oil

ISABELLE DE VALOIS was Philip III of Spain's consort, and was probably seen and even sketched by Rubens during his visit to Spain in 1603. This portrait, which has been attributed to Rubens, and to his studio, could well have had major contributions from painters other than Rubens, using Rubens' sketches and notes. The costume suggests a time in the first decade of the 17th century for the picture, while the style is more stiff and formal than the approach Rubens developed during his years in Italy as court painter to the Duke of Mantua.

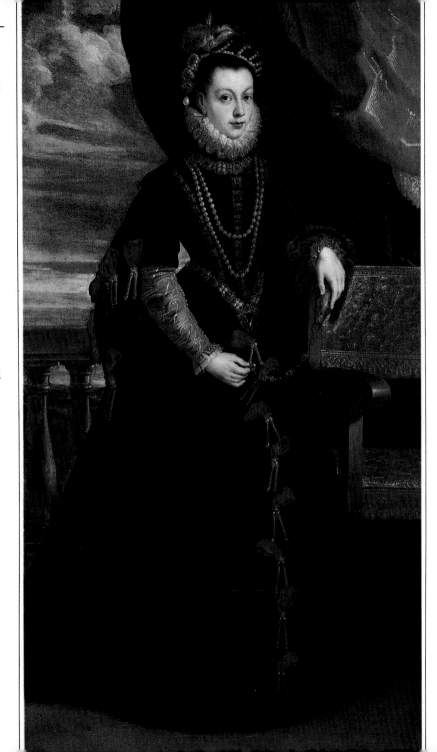

Detail

▷ **St George and the Dragon** 1606-10

Oil on canvas

IN THIS EARLY VERSION by Rubens of the familiar Christian allegory, depicted by many artists before and again by him in around 1630, St George is a lusty warrior, his horse a suberb animal with flowing mane and tail, the princess in peril a beautiful, blonde and buxom woman. Even the dragon, painted in dark tones at the bottom of the canvas, is allowed a dramatically gaping jaw and a pair of wild, staring eyes as its strangely human hand clutches at the brave knight's broken lance, buried in its throat. The artist's taste for drama and violent action, decorated with many a richly coloured flourish of his brush, shows clearly here, along with his interest in depicting movement and a highly-charged emotional atmsphere. The painting shows Rubens anticipating the Baroque style of central Europe by a generation.

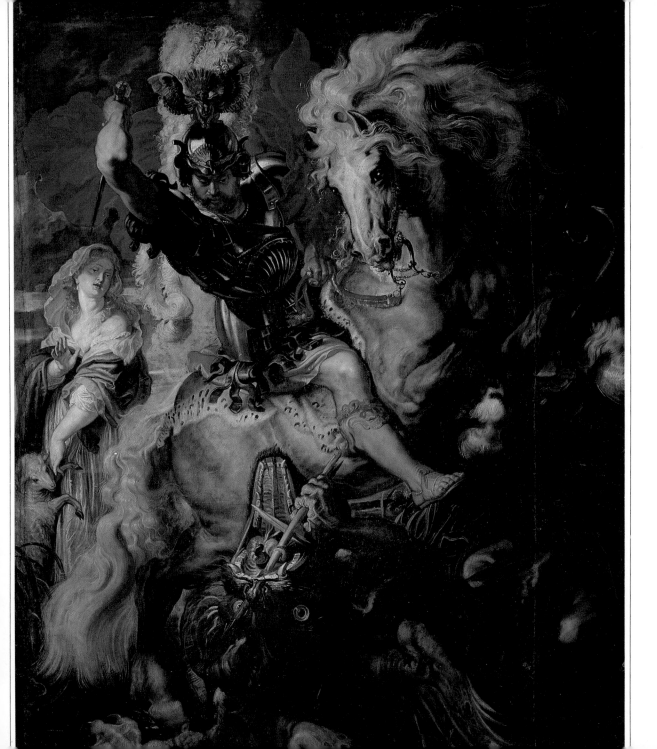

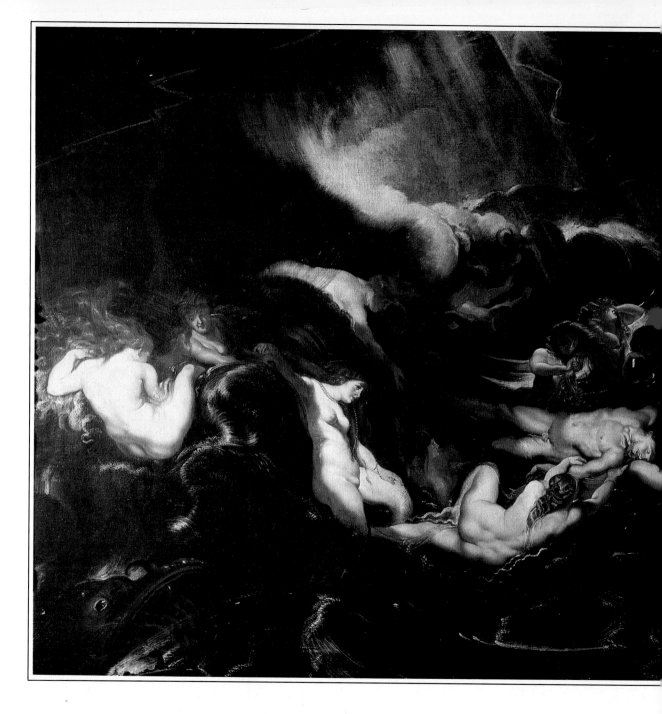

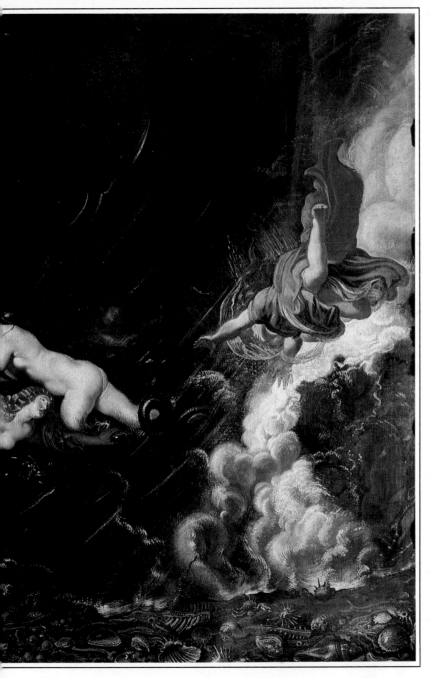

◁ **Hero and Leander** c.1607

Oil

IN THIS SPLENDIDLY dramatic painting, full of the creatures of sea mythology – sea horses, nereids (sea nymphs) and wind gods – Rubens is recounting a popular tale from classical mythology: the story of the star-crossed lovers Hero and Leander. The style of painting shows the young Rubens under the influence of the Italian artists he so admired but still able to give his picture great originality by the strength of his own imagination. The picture shows the corpse of Leander, drowned while swimming the Hellespont to reach his beloved Hero, being carried through a tumultuous sea by a wave of nereids, while the distraught Hero hurls herself from her tower to her death in the storm-tossed waters below.

▷ Adoration of the Magi
1609-10

Oil

FOR MANY, THIS IS the most moving and beautiful of the twelve versions of this New Testament subject painted by Rubens in his lifetime, some ten of which survive as altarpieces. This one was painted for the Council Hall of Antwerp. The Magi (wise men), surrounded by their retinues of servants and horses and bearing costly gifts of gold, frankincense and myrrh, seem to fill the canvas. But Rubens has so concentrated the light of the painting on the Christ Child, held up by the Virgin to receive the adoration of the great men, that it is His tiny form which dominates the picture. It is clear from the spontaneous freshness of his approach in each of his versions of the Adoration of Christ that Rubens never tired of the subject: always there was something new for him to say. Over the years, he tended to discard 'classical' settings for the lowly stable, indicating instead perhaps an ordinary wall, or a wooden rafter. He also introduced simple domestic animals, such as the ox and the ass, into the scene.

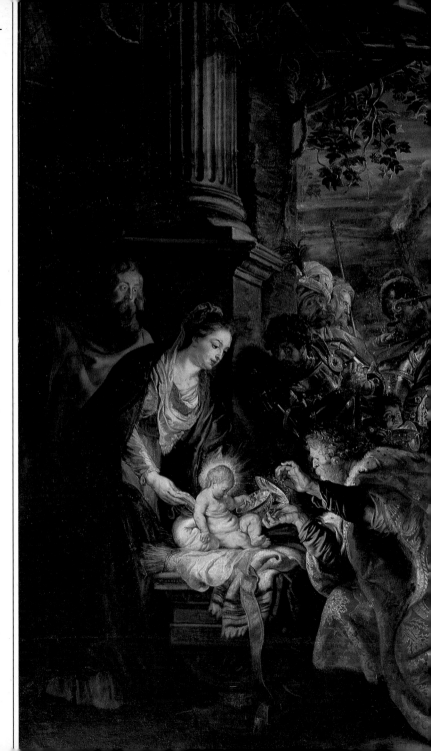

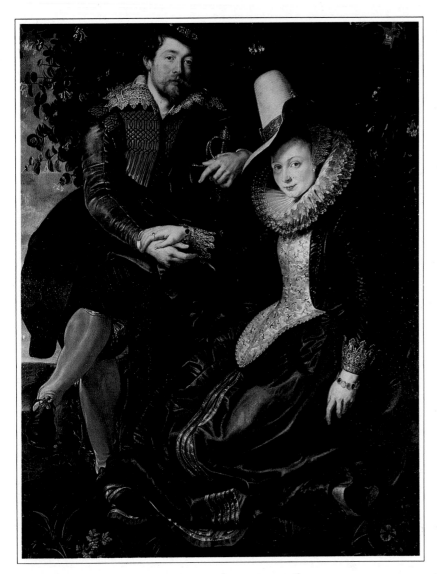

◁ **The Artist and his Wife, Isabella Brant, in the Honeysuckle Bower** 1610

Oil on canvas, mounted on oak

RUBENS MARRIED the charming Isabella Brant, daughter of an Antwerp lawyer and city alderman, in September 1609. Peace had now come to the war-torn Netherlands and Rubens soon decided that, rather than return to Italy, he would stay in Antwerp and put down roots: hence his marriage, and the building of a splendid new house on the Wappen in Antwerp. In this wonderfully confident painting, Rubens records his marriage: it is a handsome and clearly well-off couple he is portraying, romantically seated in a bower of honeysuckle. They were to live a happy life in Antwerp for seventeen years, producing three children, before Isabella's untimely death in 1626.

▷ **The Descent from the Cross**
1611-14

Oil on canvas

THIS SUPERB PAINTING is the centre panel of a triptych painted for the municipal chapel in Antwerp Cathedral. It was a major work for Rubens, commissioned by the burgomaster of Antwerp. This painting shows in grave and powerful tones the body of Christ being taken down from the cross after the Crucifixion. The painting, Rubens' first real masterpiece, is strongly reminiscent of the work of the great Caravaggio (who died in 1609), which had so profound an effect on Rubens when he encountered it in Italy. Rubens was particularly struck by Caravaggio's masterly treatment of light and shade, though Rubens tended to soften the contrast between the two in his own pictures. In the period he painted it, Rubens also painted a second great religious triptych, *The Raising of the Cross*.

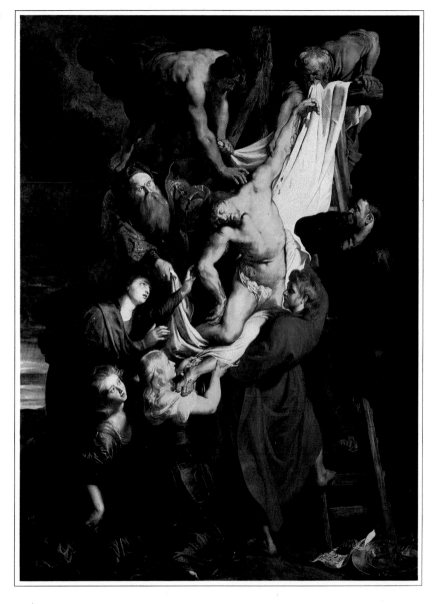

▷ The Family of Jan Brueghel the Elder 1613-15

Oil on panel

JAN BRUEGHEL, called 'Velvet' Brueghel, came from a family of Flemish painters, and was an old friend of Rubens. Both had been to Italy, though the influence of that country's art was much less important to Brueghel than it was to Rubens. Brueghel achieved fame in his lifetime as a painter of still-lifes and of landscapes, full of busy figures going about the many tasks of everyday life. Today, he is best remembered for the many works on which he collaborated with Rubens, including *Adam and Eve in Paradise* (pages 36-7). Rubens attractively informal picture of Jan Brueghel, his wife Catharina and two of their children, Peter and Elizabeth (another son, also called Jan, became a painter, like his father). By showing the family's hands and arms lovingly intertwined, Rubens beautifully conveys the sense of a closely-knit family.

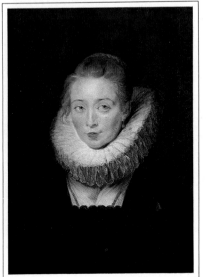

◁ Portrait of the Maid of Honour to the Infanta *c.*1612-20

Oil

THE INFANTA ISABELLA, wife of the Archduke Albert and governor with him of the Spanish Netherlands, had early recognized Rubens' abilities as a painter and a diplomat, sending him on his first secret diplomatic journey to Prince Maurice in the Dutch Republic as early as 1620. Rubens painted several portraits of the Archduke and Archduchess and of members of their court, including this lovely maid of honour.

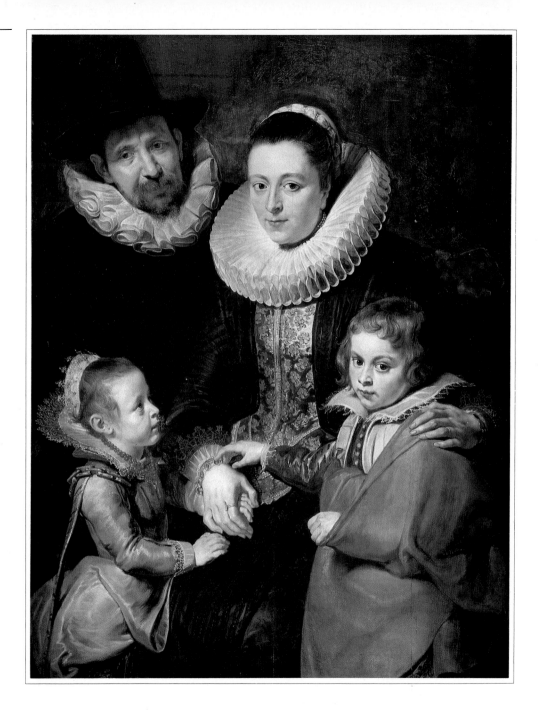

▷ **The Holy Family with Saint Elizabeth and Saint John the Baptist** 1614-15

Oil on panel

PAINTED FOR THE ORATORY of the Archduke Albert, Regent of the Spanish Netherlands, in the ducal palace in Brussels, this picture shows the Holy Family – Joseph, the Virgin Mary and the baby Jesus – with Saint Elizabeth and her son, St John (John the Baptist), on her knee. The child Jesus seems to be blessing John, foreshadowing the baptism of Christ by John the Baptist. Rubens painted this subject many times, perhaps to draw his own happy domestic life into his work. In this picture, both children are painted with great realism and in loving detail, suggesting that Rubens used his own sons, Albert and Nicolas or, at least, the many studies he had done of them in babyhood, as the models for the children in the picture.

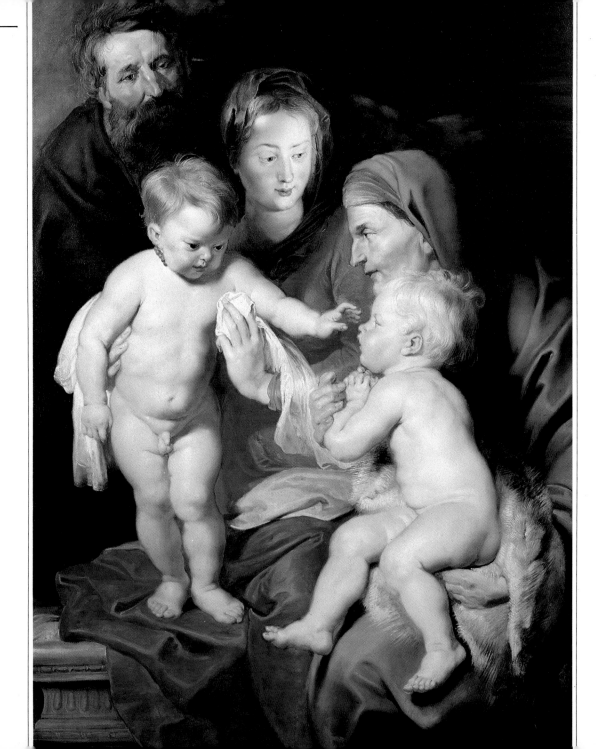

▷ The Flight into Egypt 1614

Oil

RUBENS HAS INSTILLED great tension and movement into this picture of the Holy Family's flight from the soldiers of King Herod into Egypt. He has chosen a night setting, with a small stream to reflect the light from the moon. There is a halo of light around the Christ child but neither that nor the moonlight is sufficient to dispel the sense of danger imparted by the darkness of the night and the shape of the pursuing horsemen. Joseph's movement is forward, but his anxious glance is backwards, over his shoulder. As if to lessen the tension, Rubens has introduced supernatural help, in the shape of two angels, one to lead Mary's ass, the other to point the way to Egypt and safety. Rubens is thought to have painted this picture in memory of an old friend, the painter Adam Elsheimer who had died in great poverty; Elsheimer had himself done a painting of this subject, which Rubens greatly admired.

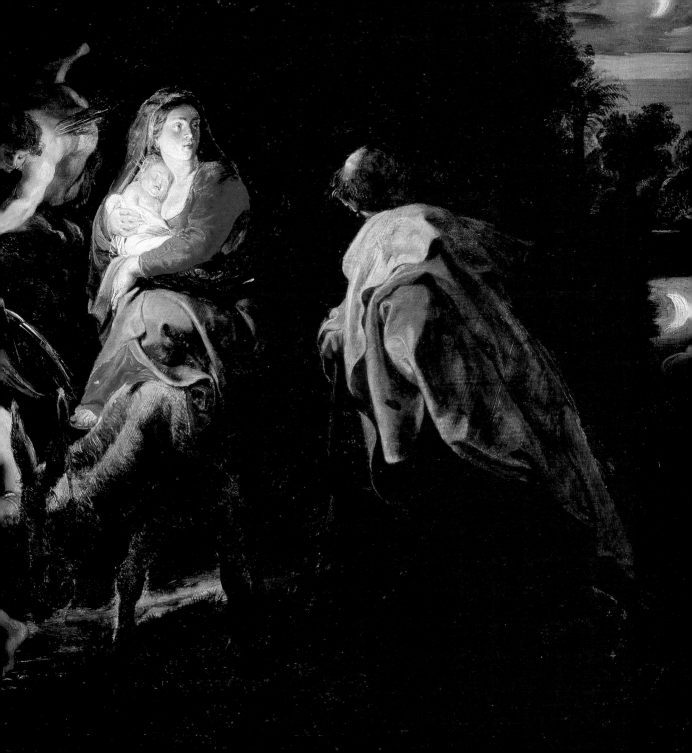

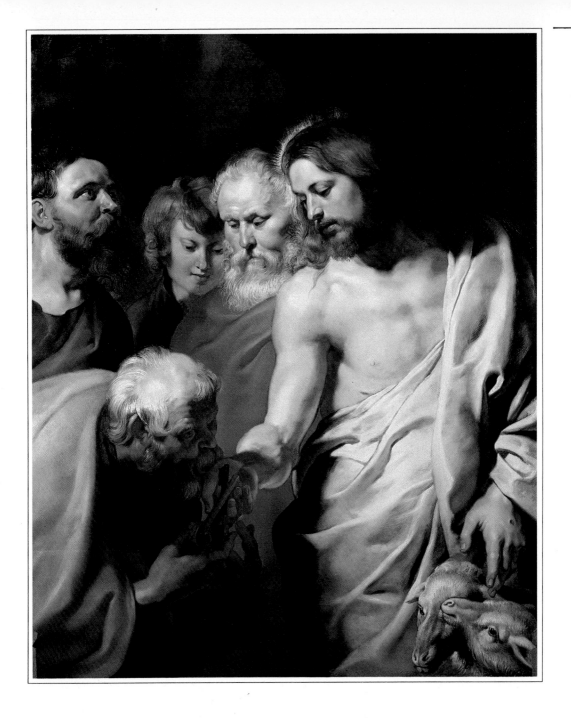

◁ **Christ's Charge to Peter** c.1614

Oil on panel

'FEED MY SHEEP,' Christ directed his disciple Simon Peter, handing on to him the keys of His kingdom. It was the third occasion he showed himself to his disciples after he had risen from the dead. The scene is the memorable climax to the Gospel of St John and Rubens has painted it with a direct and simple dignity, charged with emotion. The work was commissioned by Nicolas Damant, who placed it in the chapel of the Holy Sacrament in the Church of St Gudule in Brussels. Jan Brueghel II included the painting in a work of his own, *A Picture Gallery*, and there are copies of it in other art collections.

Farmyard with a Farmer Threshing, and a Hay Wagon c.1615

Chalk

▷ *Overleaf pages 28-29*

RUBENS DID MANY hundreds of drawings in his lifetime, most of them studies for paintings, either for the whole painting or for details in them – perhaps people doing the things he would be including in the painting or details of furniture, clothing, even trees and plants. The hay wagon in this carefully detailed chalk drawing, for instance, was used in at least three oil paintings of country life scenes, including *The Prodigal Son*, painted around 1620. (The man threshing, on the other hand, has not been identified in any painting by Rubens.) The drawing is mainly in black and red chalk but with touches of blue, yellow and green added.

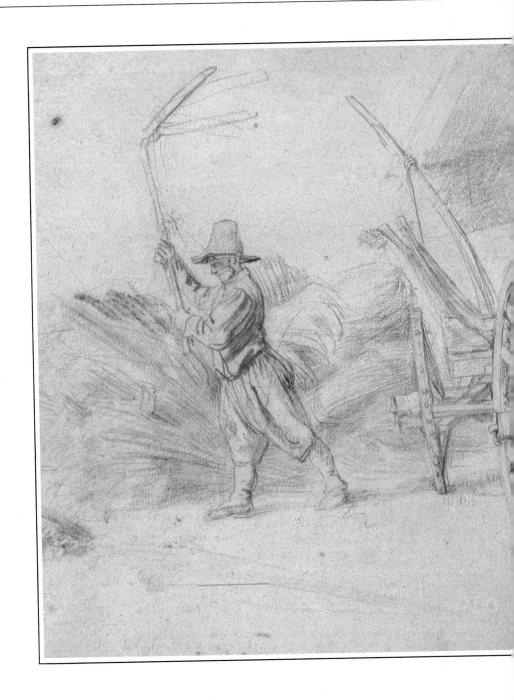

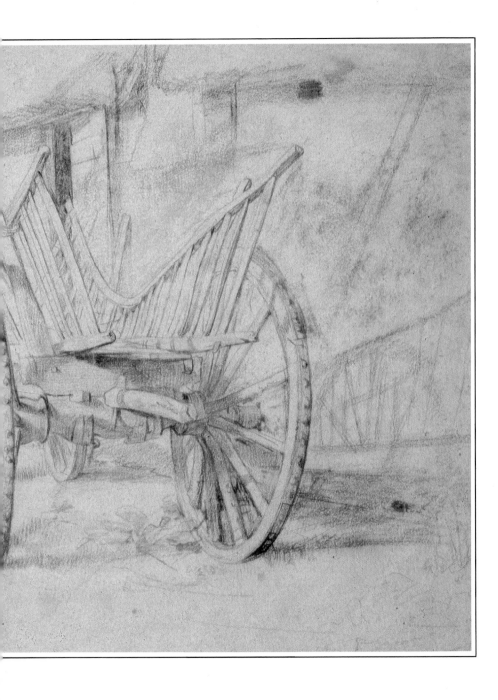

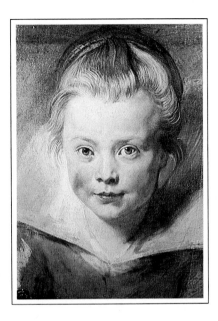

△ **Head of a Child** c.1616

Oil

IN RUBENS' GREAT volume of work, his studies of children stand out in testimony to the warmth of his nature and the breadth of his human understanding. This painting is thought to be a study of his daughter, Clara Serena, clearly a lively and mischievous little girl. Her death in 1623 at the age of twelve was a great blow to Rubens, who dearly loved all his children. The freshness of the painting and the impression it gives of the wonderful innocence of childhood make this an exceptional portrait by any standard.

▷ **The Rape of the Daughters of Leucippus** c.1616-19

Oil on canvas

RUBENS AS A pioneer of the Baroque is very much in evidence in this splendidly vigorous painting, which depicts the mythological half-brothers, Castor and Pollux, abducting the daughters of a king of Messene (abduction being the original meaning of rape). All is movement and action: the horses rear and snort as the two Dioscuri reach down for their female prey. The contrasting surfaces of armour, fabric, horsehair and female flesh, depicted with every curve, every dimple clearly delineated, provide the picture with wonderfully tactile textures. Rubens has achieved a brilliantly symmetrical balance in the picture. The gleaming white flesh of the two women, carefully separated in the picture, form a mass of light in the centre, while the two male figures and their horses, each held by a putto (a child in Renaissance art), form darker masses on either side of the women.

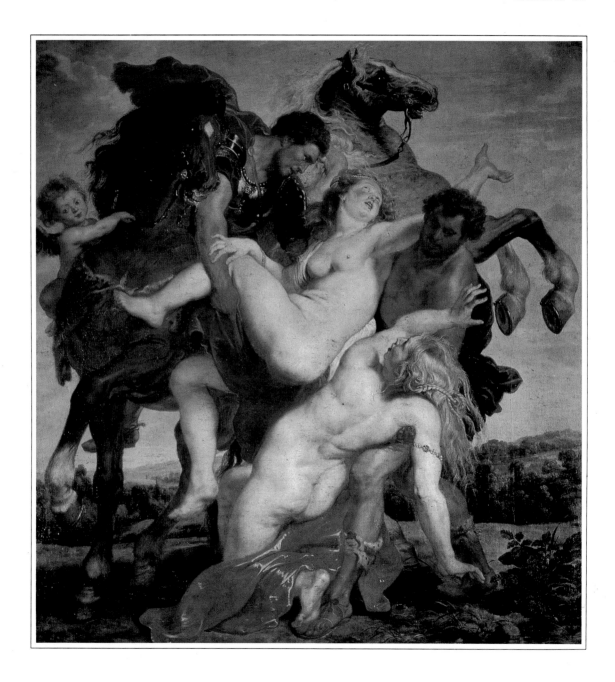

▷ St Barbara Fleeing from her Father 1620

Oil sketch

ST BARBARA WAS one of those women in the early history (or legend) of the Church who achieved sainthood through martyrdom. She was a beautiful maiden locked up by her father in a tower to discourage unwanted suitors. When she was discovered to have become a Christian, her father tried to kill her but she was miraculously carried out of his reach. Her father then reported the poor girl to the authorities, who tortured her in a vain attempt to make her renounce her faith. Her father was ordered to put her to death, which he did – only to be struck by lightning and reduced to ashes in retribution. The cult of St Barbara became widespread from about the 9th century; in time she came to be invoked against danger from lightning, then became patron saint of miners and gunners. She is still regarded as patron saint by artillery companies in numerous countries. Rubens included his version of her story in a series of painted ceiling panels he was commissioned to do for the great new Jesuit Church in Antwerp, a modern building in Italian style.

▷ A Lion Hunt

Oil

RUBENS BEGAN painting animal pictures as early as 1610. In 1621, Rubens provided for that increasingly discerning patron of the arts, the Prince of Wales (later Charles I) another picture of a lion hunt for hanging in the prince's private picture gallery, which the prince had chosen not to accept, since there was more of Rubens' assistants' work in it than his own. Among Rubens' animal paintings were many ferociously dynamic scenes of animal hunting, including lions, tigers and even a hippopotamus and a crocodile, all of them showing an unmatched ability to depict animals in action. Early in his life he had become something of a connoisseur of horses, perhaps because his patron, the Duke of Mantua, had kept a famous stable. Rubens' close study of the anatomy of the horse was followed by studies of other animals, including wild beasts he was able to observe in the menageries which were a regular part of royal residences in his day.

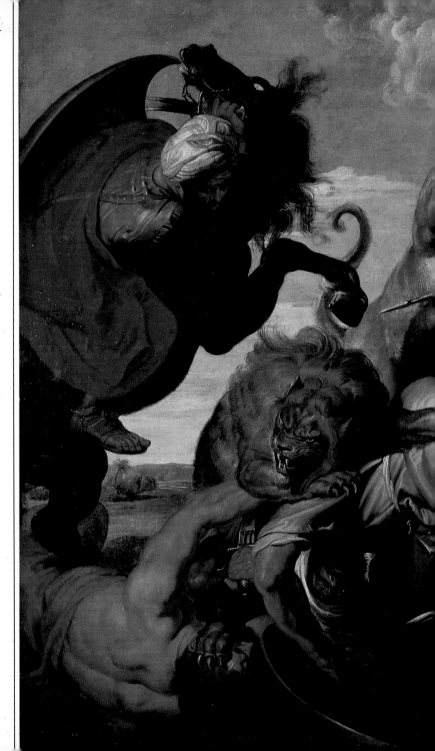

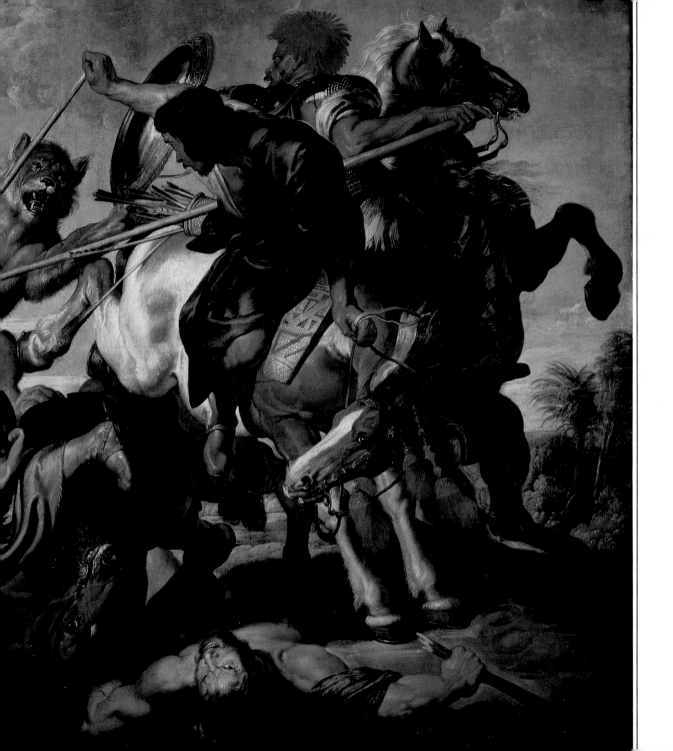

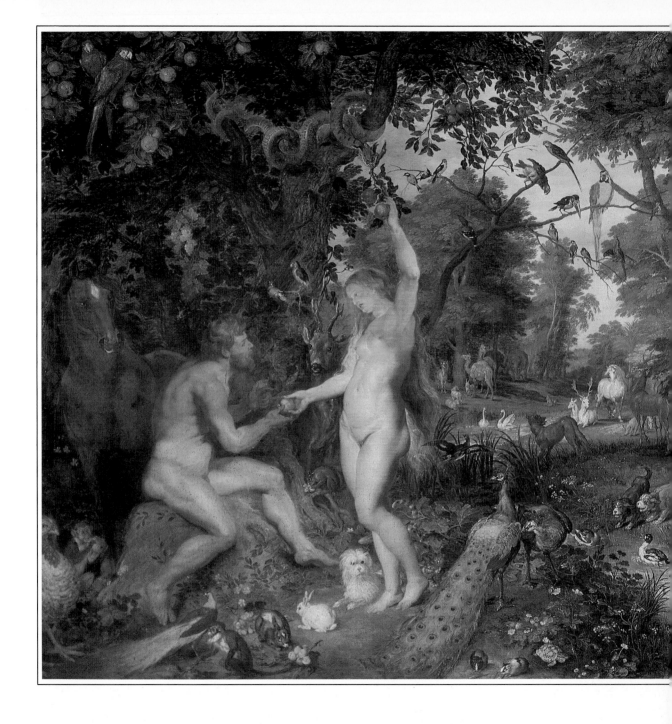

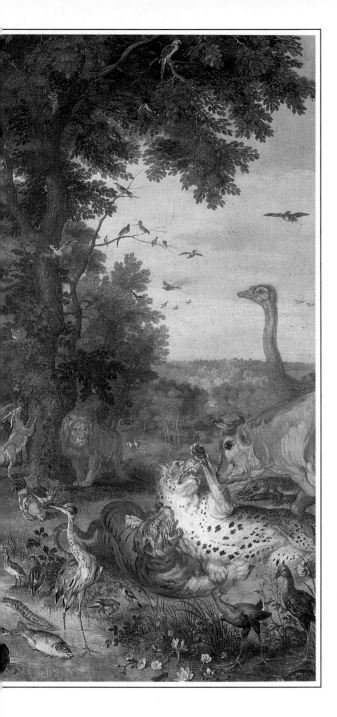

◁ **Adam and Eve in Paradise**
c.1620

Oil

THIS PAINTING is one of the
most charming and effective
results of the artistic
collaboration between Rubens
and his friend Jan Brueghel
the Elder, which was carried
on over about a dozen works.
Brueghel painted the
background landscape and the
many birds and animals which
populate it in such lively
profusion and Rubens put in
the delightfully innocent
figures of Adam and Eve,
about to eat the forbidden
fruit of the Tree of Knowledge.
It was not unusual in Rubens'
time for artists to collaborate
on work, while many
important artists employed
pupils in their studios to carry
out work under their master's
supervision. To have two
recognized and distinguished
artists working on one picture,
as in this *Adam and Eve*, would
have been a popular move in
the Antwerp of Rubens' day.

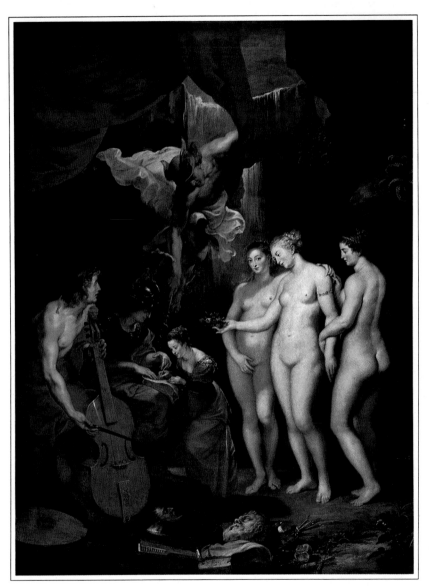

◁ The Education of Marie de' Medici 1622-5

Oil on canvas

RUBENS WAS DELIGHTED to be commissioned by the Queen Mother of France, Marie de' Medici, to paint a series of paintings illustrating her life, for hanging in the magnificent new residence, the Luxembourg Palace, she was having built in the Italian style in Paris. He went to Paris in 1622 to discuss the work with the Queen, whose wedding by proxy to Henry IV of France, he had attended more than twenty years before. Marie was intent on giving a good account of herself to posterity. In choosing Rubens to illustrate the achievements of her life, Marie de' Medici was ensuring that posterity would certainly have a magnificent memorial to her. This painting, third in the series of twenty-one great canvases, shows Minerva, Apollo and Mercury instructing the young Marie in reading, music and eloquence, while the Three Graces offer her beauty.

▷ **Henry IV Receiving the Portrait of Marie de' Medici**
c.1622-5

Oil on canvas

RUBENS CONTINUES the Classical mythology tone of his Marie de' Medici series by having two emissaries of Juno, goddess of Marriage, showing to Henry IV a portrait of his future bride. Although Rubens was able to base his portraits of Marie de' Medici on reality, albeit much glamourized and highly flattering, he had to rely on drawings and portraits to produce his own portrait of Henry IV, whom he had never seen in real life. Henry had been too busy to attend his own marriage to Marie de' Medici in Florence and had sent a proxy, the Grand Duke of Tuscany.

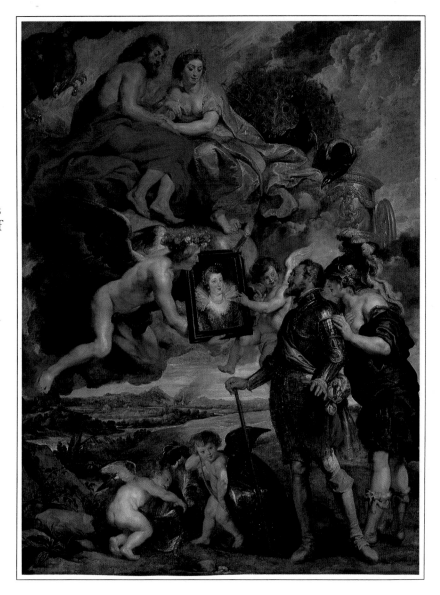

▷ Detail from **The Arrival of Marie de' Medici at Marseilles**
c.1622-5

Oil on canvas

HAVING DEPICTED Marie de' Medici's marriage ceremony in realistic, though gorgeously painted, tones, Rubens returned to Classical mythology to depict the new Queen's arrival in France. These typically Rubensesque Naiads, accompanied by Neptune with his trident and an assortment of other mythological sea creatures, escorted Marie's ship into harbour, where she was welcomed by the helmeted figure of France. The goddess of Fame hovered overhead, blasts from her trumpets announcing the Queen's presence to the people.

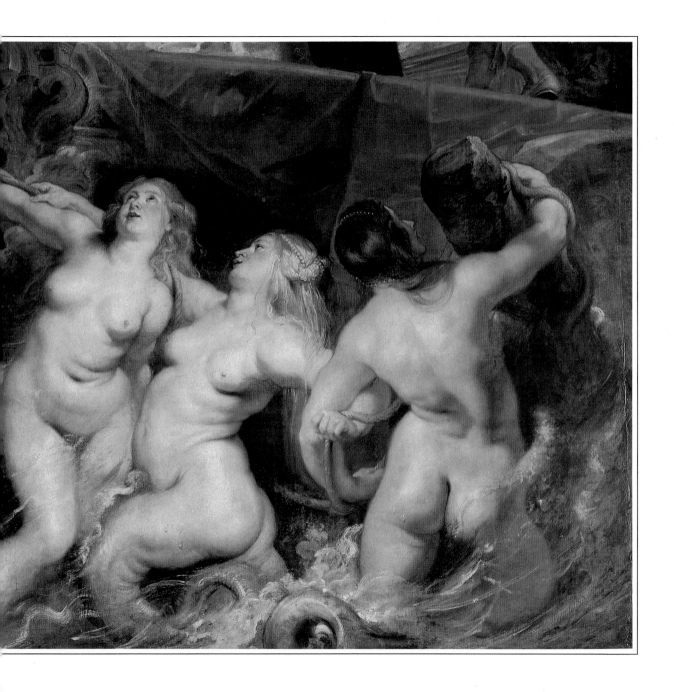

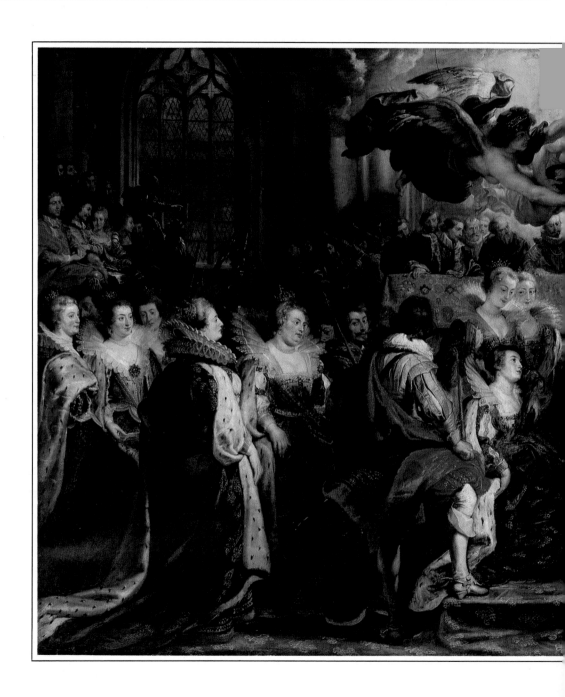

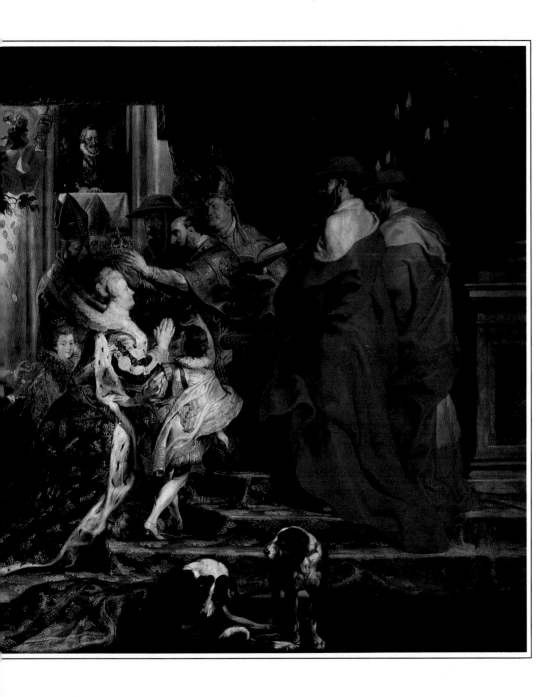

▷ The Triumph of Juliers c.1622-5

Oil on canvas

THIS IS Marie de' Medici in triumph: a superb equestrian portrait to emphasise Marie's point that, just as her late husband had done, she was able to triumph over France's enemies in battle. The last pictures in Rubens' great sequence depicting the life of Marie de' Medici were delivered to Paris early in 1625, where Rubens stayed long enough overseeing their framing and hanging to witness the marriage by proxy of Marie's young daughter, Princess Henrietta Maria, to King Charles I. The paintings have become one of France's greatest artistic treasures and a triumph of Baroque art.

The Coronation of Marie de' Medici c.1622-5

Oil on canvas

◁ *Previous pages 42-3*

SINCE MARIE DE' MEDICI was the second wife of Henry IV, he had already been crowned king some years before her arrival in France. She insisted on a separate coronation to enhance her position as Queen of France. Rubens' painting of the occasion is a brilliant recreation of the splendid, rich pageant of the coronation ceremony. Naturally enough, he has chosen to show the actual moment of the crowning of the queen, with her kneeling figure dominating the centre of the vast picture. On either side of her stand her son and daughter, and trainbearers and beautiful maids of honour crowd behind her. Even Henry IV's first wife, Marguerite de Valois who had agreed to the annulment of her marriage because she could not bear the king an heir, is in the picture, a jewelled coronet on her head and a look of dignified sadness on her face. The king himself looks down on the ceremony from a balcony above the queen.

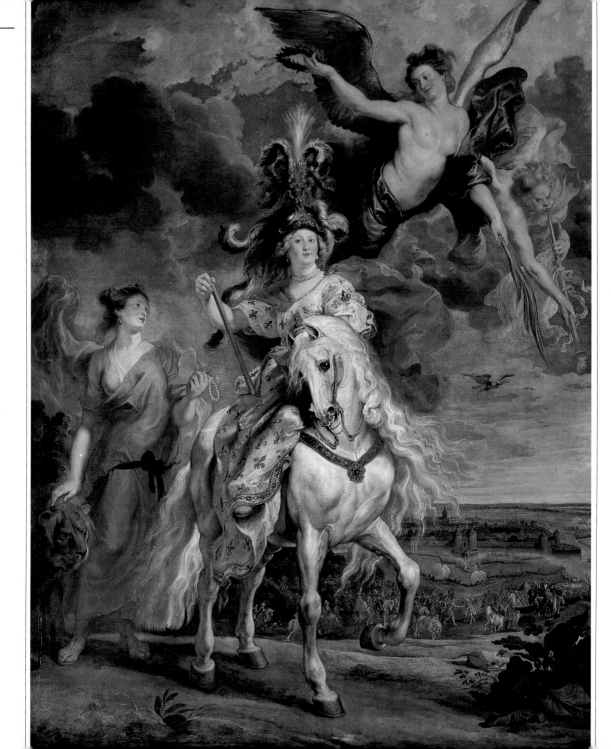

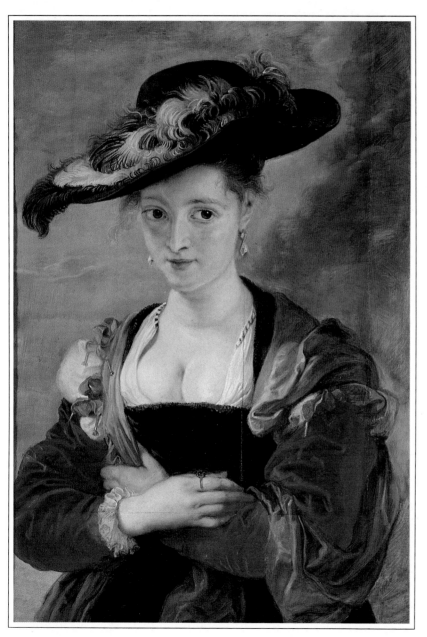

◁ **Le Chapeau de Paille**
c.1622-5

Oil on panel

OBVIOUSLY, IT IS not a straw hat but one of black felt that the lovely young girl, who may have been Susanna Fourment, later to become Rubens' sister-in-law, is wearing in this famous portrait. The title has a long provenance and may result from a misinterpretation of the original French. Whatever the origins of its title, there is no argument over the brilliance of the portrait: 'a miracle of youthful charm in the most radiant *chiaroscuro*', as the 19th-century critic, Jacob Burckhardt described it. An open-air picture, with just the sky for background and a light breeze to stir the girl's hair and the feather in her hat, this is one of Rubens' greatest portraits, still alive with the force of his genius. The citizens of Antwerp are said to have raged at the painting's loss when it was bought by a London dealer from the estate of its Belgian owner. Sir Robert Peel bought it from the dealer in 1823 and it was still in his collection when bought for the National Gallery, London in 1871.

▷ **Self-Portrait** c.1624

Oil on panel

THIS PICTURE is so similar to
one requested from Rubens by
the Prince of Wales, later
Charles I, in 1623, and now in
the Royal Collection at
Windsor Castle, that it may
well be a copy by the artist. It
is thought that the prince may
have requested a self-portrait
from Rubens partly as
compensation for his refusal, a
couple of years earlier, to
accept for his private gallery a
picture of a lion hunt offered
to him by Rubens. The prince,
a discerning connoisseur and
patron of contemporary
artists, already had several
works by Rubens in his
collection and considered the
hunt picture to be 'a peece
scarse touched by his [Rubens']
own hand' and therefore not
suitable for hanging in his
gallery. A self-portrait by one
of Europe's leading painters
would be a different matter
altogether. Some time later,
Rubens, in telling of the
persistence with which the
Prince of Wales had made his
request, said that he was 'the
greatest amateur (lover) of
painting among the princes of
the world'.

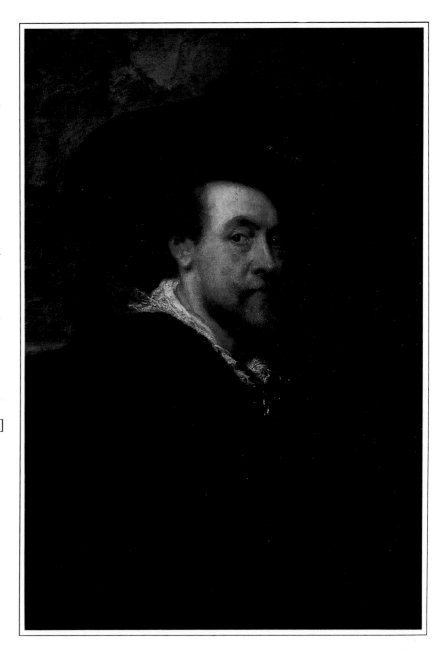

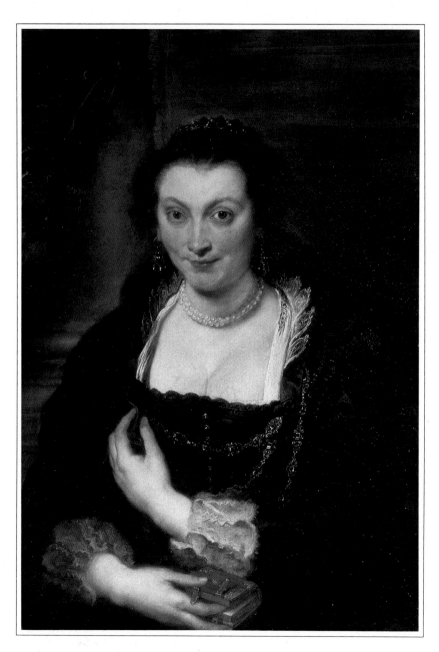

◁ **Isabella Brant, Whom Rubens Married in 1609**
c.1625

Oil

CHALK DRAWINGS in Rubens' collection indicate that he painted this portrait of his first wife not long before her death in 1626. It is the last portrait he painted of her. Although still charming, she is clearly a much older woman than the one painted with her husband 'in the honeysuckle bower' in 1610. She died suddenly in the summer of 1626, perhaps of the plague which had been prevalent in Antwerp, and her death robbed Rubens of a domestic happiness he had known for seventeen years. 'Truly, I have lost an excellent companion,' he wrote to a friend. 'She had no capricious moods, no feminine weakness, but was all goodness and honesty.' This portrait preserves that goodness and honesty most movingly.

▷ **Portrait of Rubens' Son**
c.1624

Oil

RUBENS PAINTED many pictures of his children, of whom he had eight in all: three with Isabella Brant and five with his second wife, Hélène Fourment. This portrait of a small boy, obviously very proud of his splendid red cloak, would seem to be his younger son by Isabella Brant, Nicolas. Rubens painted a superb, sensitive double portrait of his sons, Albert and Nicolas, shortly after their sister Clara Serena's death in 1623. This portrait would seem to have been painted around the same time or perhaps a little earlier.

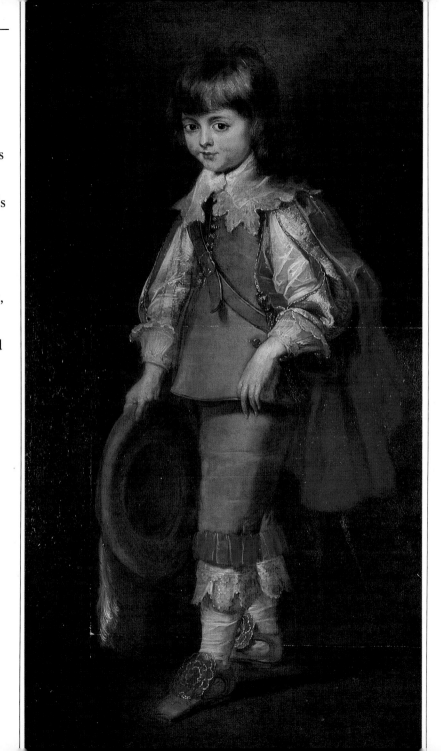

Detail

▷ **The Duke of Buckingham Escorted by Minerva and Mercury to the Temple of** *Virtus* c.1625

Oil on panel

ONCE CALLED an 'Apotheosis of the Duke of Buckingham', presumably because it was thought to date from after the duke's assassination at La Rochelle in 1628, this oil sketch has been identified as a sketch by Rubens for a great piece for the ceiling of the duke's closet in his splendid York House, a gift from James I, whose favourite the duke was. Buckingham, in Paris in 1625 to attend the marriage by proxy of the Princess Henrietta Maria to King Charles I, had given Rubens a sitting for chalk sketches on which the artist was to base a great equestrian portrait of the duke. The commission to provide paintings for York House may have been given to Rubens at the same time. The iconography of the ceiling painting includes Virtus and Abundance awaiting the duke, while the Three Graces offer him a crown of flowers and the helmeted figure of Envy tries to pull him down.

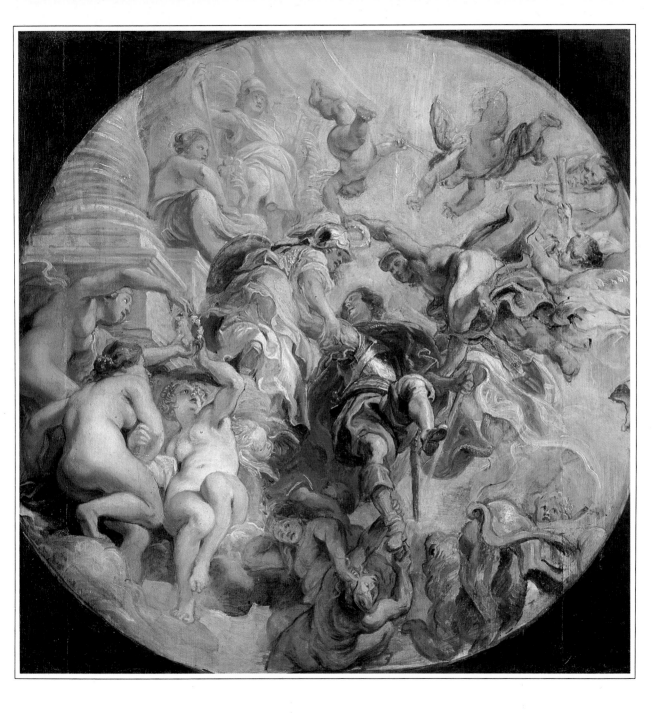

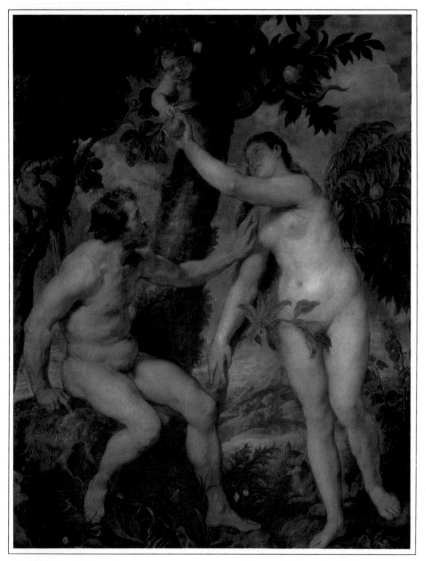

◁ **Adam and Eve** c.1628-9

Oil on canvas

OF ALL THE Italian painters studied by Rubens, the one who influenced him most was the Venetian, Titian. While he was in Italy, Rubens made numerous copies of paintings by Titian; when he himself had become a wealthy man, Rubens bought several paintings by Titian, ten of which were still in his house at the time of his death. This version of Titian's *Adam and Eve* is more than just a simple copy, for Rubens, working in his own studio, has felt confident enough to make some changes; his figures are less stiffly formal than Titian's and he has added movement and shade to the colouring.

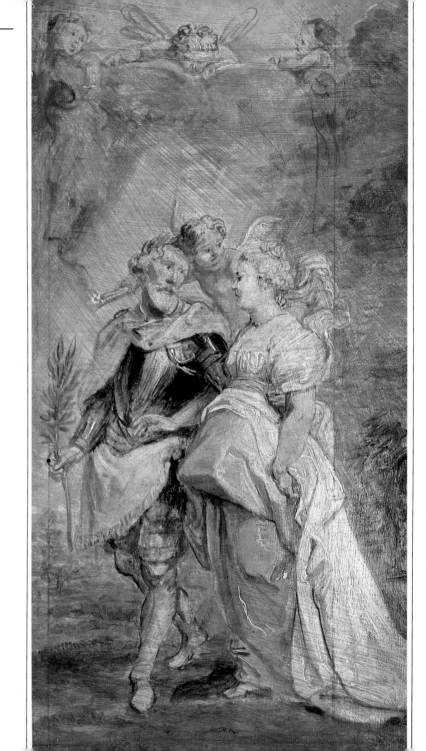

▷ **The Union of Henry IV and Marie de' Medici** c.1628-31

Oil on panel

WHEN MARIE DE' MEDICI was planning the decoration of her new Luxembourg Palace in Paris, she set aside two galleries to hold paintings depicting the lives of herself and her husband, Henry IV. She commissioned the cycle of paintings of her own life from Rubens first. The second cycle, twenty-one paintings showing scenes from the life of Henry IV, never got beyond the stage of discussion, a few sketches and six unfinished canvases, apparently because Louis XIII's minister, Cardinal Richelieu, objected to the enormous cost of the Luxembourg Palace project and put many obstructions in the way of its completion. This sketch was Rubens' outline for what should have been the final painting in the Henry IV series and is believed to have been based on an engraving by Dürer, *The Promenade*. The figure at the top of the sketch is Hymen, god of Marriage.

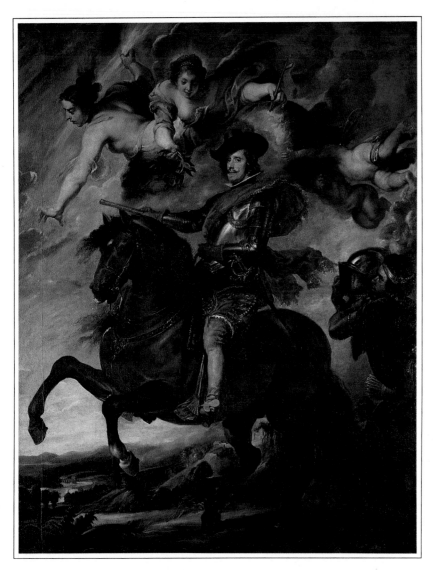

◁ **Portrait of Philip IV**
1628-9

Oil on canvas

PHILIP IV, WHO succeeded his father as king of Spain in 1626, granted Rubens several audiences in 1628-9 when Rubens visited Madrid in the dual capacity of artist and diplomat (employed by the king's aunt, the Archduchess Isabella, who was his regent in the Spanish Netherlands). While the diplomatic negotiations dragged on, Rubens the artist employed his months in Spain very profitably. Not only did he renew his acquaintance with the many great works by Italian artists in the royal collection, but he met the rising young Spanish artist, Velazquez. He also found time to paint many superb portraits, including those of every member of the Spanish royal family for the Archduchess Isabella, who had never met her nephew, the king. This fine equestrian portrait of Philip IV was one of five portraits of the king painted by Rubens during his stay in Madrid.

The Ceiling of the Banqueting House, Whitehall
(completed 1635)

Oil on canvas

◁ *Previous page 55*

THE SUGGESTION that Rubens should provide the ceiling paintings for the new royal Banqueting Hall in London had been mooted as early as 1621, when an Englishman, admiring Rubens' ceiling paintings in the new Jesuit Church in Antwerp, had called him 'the master workeman of the world'. It was not until 1629-30 that he received a definite commission for nine great paintings, all of which he painted in Antwerp after making and submitting many preliminary sketches. The paintings portray King James I, who had died in 1625, in various heroic aspects, with an emphasis on the Union of the crowns of England and Scotland and the King's role as a source of Justice and supporter of Religion. They were completed and sent to England in the autumn of 1635 and Rubens was paid for them – £3000 and a gold chain – in June 1638. Rubens' ceiling paintings for the Banqueting House, which have been called the crowning glory of Inigo Jones' 'faire' Palladian building, show Rubens at the height of his powers both as an artist with a deep and wide-ranging knowledge of classical allegory and as a designer on the grand scale.

▷ **Woman with an Ostrich Fan**
c.1632-5

Chalk

RUBENS' SECOND WIFE, Hélène Fourment, whom he married in 1630 when he was fifty-three and she not quite seventeen, became his most frequent model, happy to pose for him for many portraits, in many different costumes, indoors and out, with or without their rapidly growing family. This charming study in black, red and white chalk has a delightfully spontaneous air, as if Hélène wanted her husband to admire her new dress and the wonderful – and undoubtedly expensive – ostrich feather fan. The study was used by Rubens in a painting called *Conversation à la Mode* and again, slightly varied, in *The Garden of Love*.

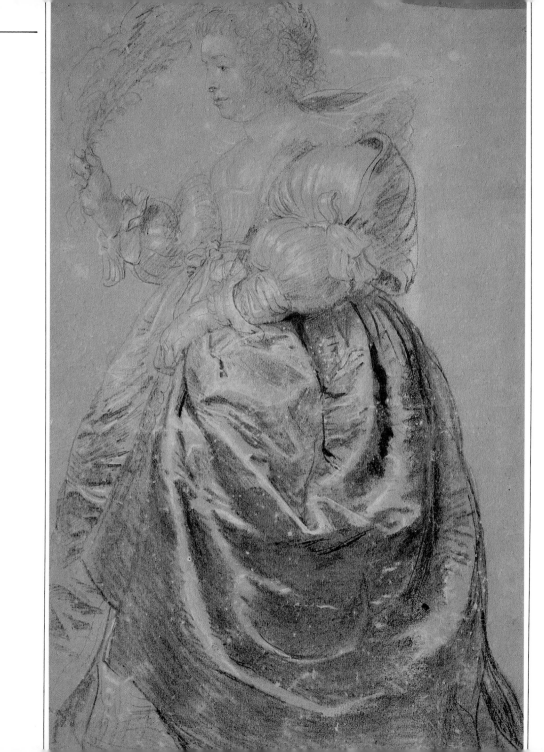

▷ **The Garden of Love** c.1632-5

Oil on canvas

THIS EXUBERANT and light-hearted scene – Antwerp's high society depicted in terms of a mythological feast complete with classical ruins – reflects Ruben's happiness in his second marriage: the dancing couple on the left of the picture, being given a helping hand by a small putto(figure of a child in Renaissance art), have sometimes been identified as Rubens and Hélène Fourment. This painting became very popular, with numerous copies being made of it and Rubens himself preparing drawings for engravings. Rubens' treatment of the subject – contemporary society pictured in terms of classical mythology – was to be taken up in the 18th century by artists such as the Frenchman Watteau.

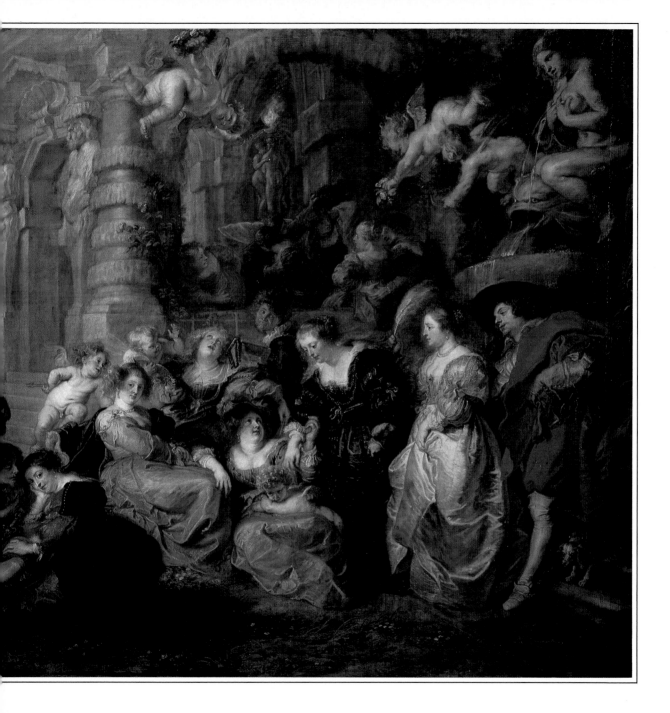

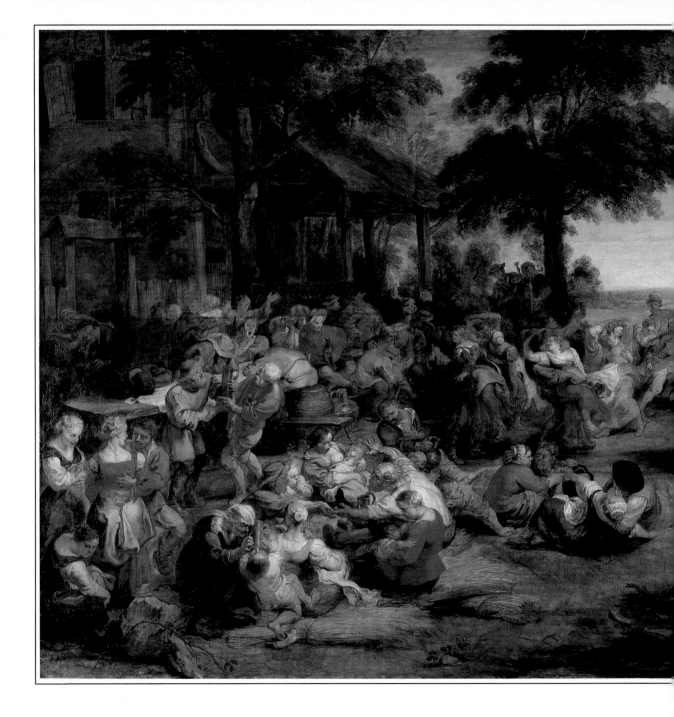

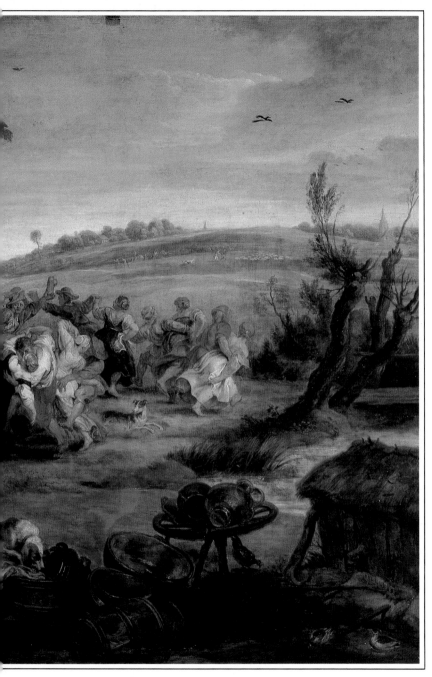

◁ **The Kermesse** 1635-8

Oil on panel

IN PAINTING this lively scene,
apparently depicting life
among Flemish peasants but
probably done largely from
imagination, Rubens was
following in a happy tradition
established in the century
before him by another Flemish
painter, Pieter Brueghel. A
kermesse was a village festival,
providing farm workers and
their families with a glorious
opportunity to let their hair
down in unrestrained and
often drunken revelry. Having
bought himself a country
property, the Château de
Steen (Het Steen), shortly after
his second marriage, Rubens
had every opportunity to
remind himself of the kind of
down-to-earth life lived
outside the more familiar,
cultured and sophisticated
society of Antwerp. To judge
by the exuberantly painted
detail in this picture, Rubens'
response was positive and
delighted.

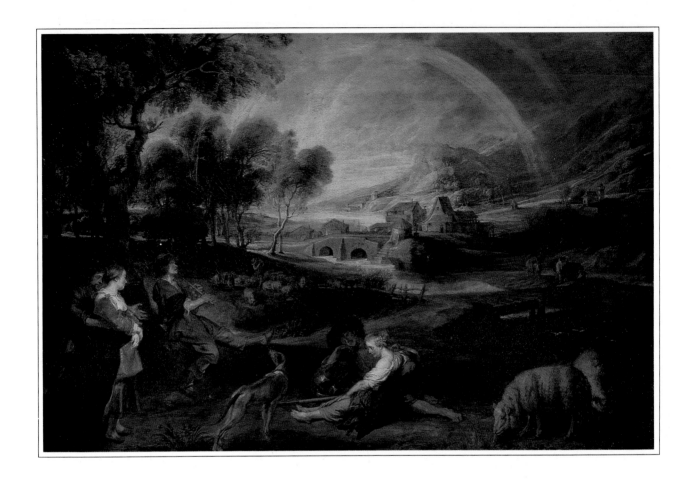

◁ **Landscape with a Rainbow** c.1635-40

Oil

IN THE LAST decade of his life Rubens came to concentrate more and more on landscape, a shift in emphasis in his work undoubtedly influenced by his new life as a country landowner. His landscapes became beautiful, sensitively portrayed expressions of his love for the countryside around his home. The effect of changing light on a scene, brought about by changes in weather or simply by the passing of the hours, fascinated him, and his handling of light and shade became miraculously delicate. In this picture he has brilliantly captured that particular clarity in the air that occurs after rain: the figures in the foreground appear bright and sharp-edged, while the green, fertile land towards the horizon is still veiled in a mist of rain.

The Judgement of Paris
c.1635-40

Oil on panel

▷ *Overleaf pages 64-5*

RUBENS' DELIGHT in the female nude is at its most sumptuous in this famous painting, one of several versions he did of this story from classical mythology (Paris gives the golden apple of discord to Aphrodite, thus choosing her as the fairest goddess of all). Here, the painting is vigorous and spontaneous, Rubens' instinctive feeling for life – both human life and the life of nature – being expressed in brilliant colours and with great warmth. The painting is thought to have found its way to France not long after it was painted and may even have been in the collection of Cardinal Richelieu; it was undoubtedly an inspiration for such French artists of the 18th century as Watteau and Boucher.

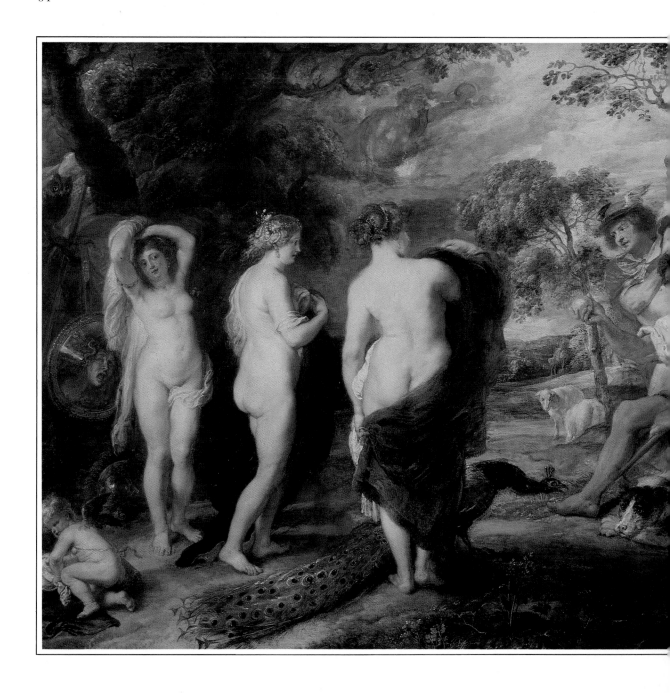

△ **Landscape by Moonlight** c.1635-40

Oil on panel

ONE OF RUBENS' great pleasures while living at his country estate, Het Steen, was to record his impressions of how the light affected the countryside at different times of day and how the very shape of things seemed to change at sunrise or sunset or, as in this painting, in moonlight. This picture is unique among Rubens' work for its absence of human life; there is just a solitary grazing horse to break the complete hold of nature on the picture. *Landscape by Moonlight* was much admired and appreciated by English artists. The painting was in England from at least 1778, when Sir Joshua Reynolds, its first recorded owner, used it as a demonstration painting in a lecture at the Royal Academy. John Constable is known to have died with his feet almost touching a print of 'the beautiful moonlight by Rubens'.

▷ The Rape of the Sabine Women c.1635

Oil

THE STORY OF the rape (abduction) of the Sabine women is one of those mythological tales written to explain an episode in history, in this case the foundation of Rome. Both Ovid and Livy included the story in their work, using it to explain how the Roman settlers came to intermarry with local tribes, of which the Sabines were one of the most threatening. According to the legend, Romulus and his followers invited local tribespeople to a festival in the Circus Maximus, then carried off the girls. Naturally, war broke out, but the Sabine women, who had not been ill-treated, intervened to restore peace. The episode featured in the work of several European artists and sculptors, this version by Rubens being among the most richly dramatic.

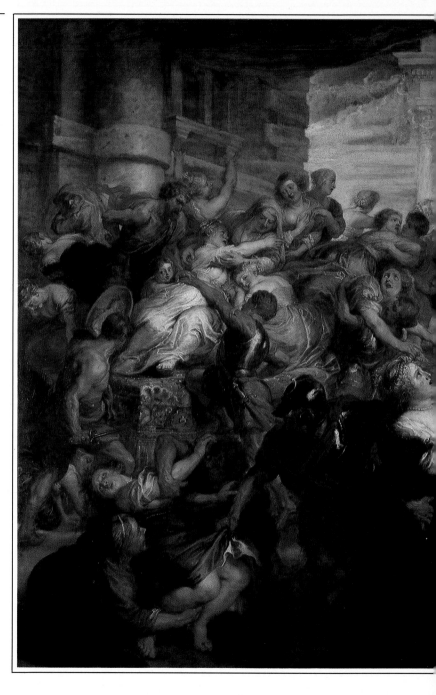

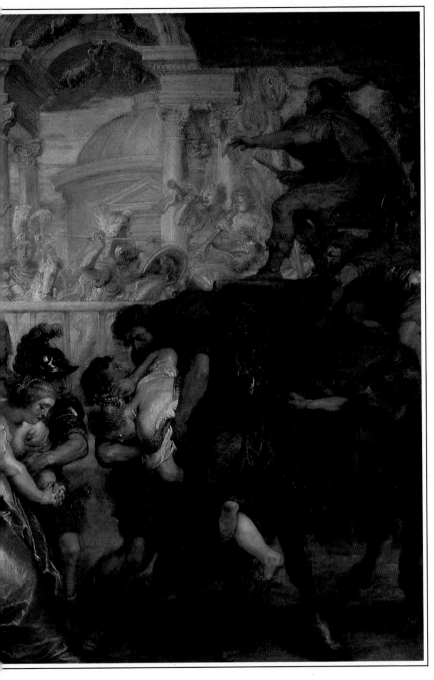

Diana and Callisto

Oil

▷ *Overleaf pages 68-9*

DIANA, GODDESS of the woods, of women and the moon (and counterpart Roman mythology of Artemis in Greek mythology) was one of the leading characters in Rubens' mythological gallery, featuring in several paintings. This one, probably painted for Philip IV of Spain, who had a very large collection of the works of Rubens, uses the story of Diana and one of her huntresses, Callisto, as an excuse to paint a large group of female nudes in his richest style. As in other paintings, Rubens has painted the women's flesh in a glorious pearl-white, setting them against a background of trees, earth and draperies painted in rich, dark tones.

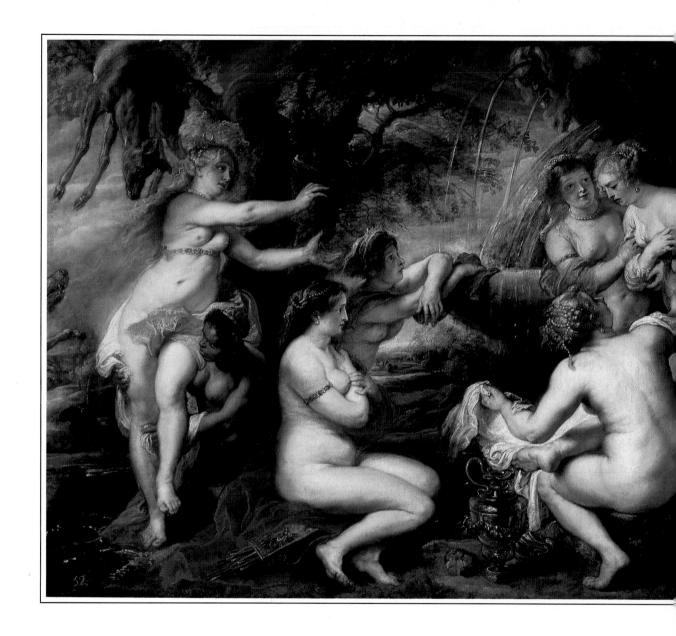

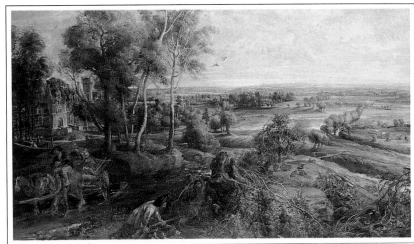

△ **Landscape with Château de Steen** 1635-7

Oil on panel

IN THE HISTORY of European painting, Rubens is outstanding in many genres but perhaps in none more so than in the landscapes of his last decade. Until Rubens, no-one had created such atmospheric effects in landscapes, and until Turner came along in the 19th century no-one was to succeed so well after him. This elaborate autumn landscape, with Rubens' much loved country house set at its edge and a beautiful, cloud-filled sky curving over it, is a richly satisfying work. There is a great suggestion of the harmony that is created when man works with nature, harnessing its beauty and fertility for his own good.

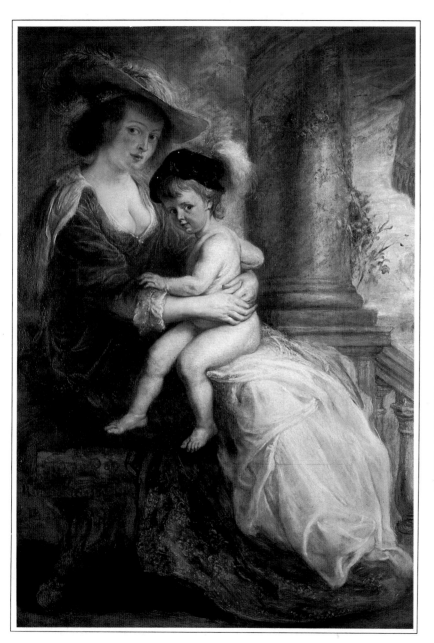

◁ **Hélène Fourment and her son Frans** c.1635

Oil

HÉLÈNE FOURMENT'S first son and third child by Rubens, Frans, was born in 1634 and was still a chubby toddler when his father painted him on his young mother's knee. Rubens painted his wife and children over and over again in the last years of his life. It was a time of great domestic contentment for him, a contentment which showed itself in the almost lyrical quality of the paintings of his family. For this painting, Rubens has introduced lightness and softness everywhere: Hélène's dress is made of some light, airy fabric, both she and Frans have a breeze-tossed feather in their hats, and light drapery and a twining plant soften the hard line of the pillar in the background.

▷ **Hélène Fourment and Two of Her Children** c.1635

Oil on panel

THE FACT THAT it is unfinished adds to the happy and informally domestic atmosphere of this simple picture: it is as if Rubens came upon his wife telling two of their children a story in the nursery, pulled out his painting materials and began rapidly to record the scene. On one level, this is just another picture of Hélène Fourment and her children Clara Joanna and Frans; because the painter is Rubens it is also a moving evocation of motherhood.

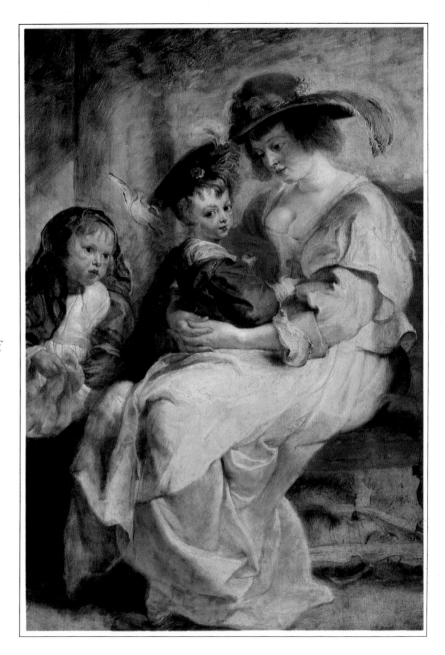

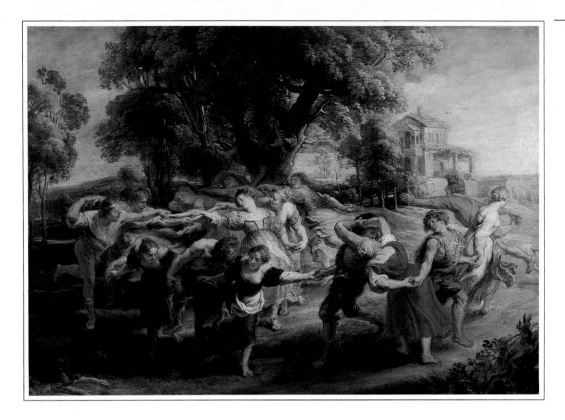

△ **A Peasant Dance** c.1636-40

Oil

THE BASIC characteristic that brings such vitality to Rubens' art is movement: there is nothing static about even the simplest picture or portrait. A subject such as this – a large group of people dancing – allows this characteristic free rein, so that we have a strong sense of the gaiety and excitement of the occasion as we look at the picture. Although Rubens almost certainly did a great many preliminary sketches for the painting and even painted one or two forerunners to it, the picture still has the spontaneous air of a newly planned work. It was a subject he enjoyed doing: once in Paris he dashed off a delightful peasant scene, on the back of which Queen Marie de' Medici wrote 'Rubens has been so kind as to paint this in my presence in half an hour'.

▷ **The Three Graces** 1639

Oil on canvas

RUBENS' JOYOUS spirit emerges most strongly in his paintings of the female nude. Sensuous, forthright and erotic, but never lascivious or banal, a Rubens nude is a tribute to the God-given beauty of the human form. Rubens painted plump women partly because they were the norm and the fashion in his day and partly because the curves and hollows of their bodies were a challenge to the artist. The flesh of his nudes is wondrously, exquisitely tinted – a delicate composition of milk and blood, it has been described – and painted with a uniquely subtle texture. This incomparable painting, one of Rubens' finest nude paintings, was done for the royal collection in Spain.

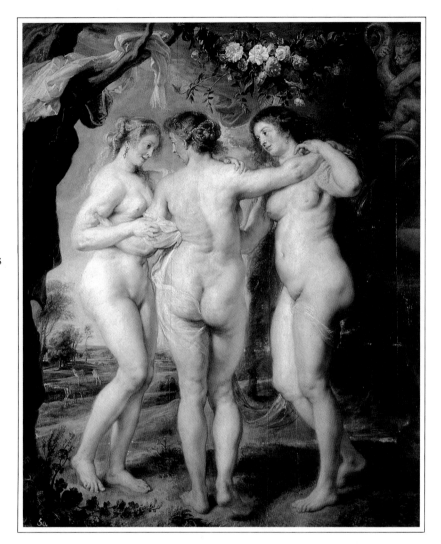

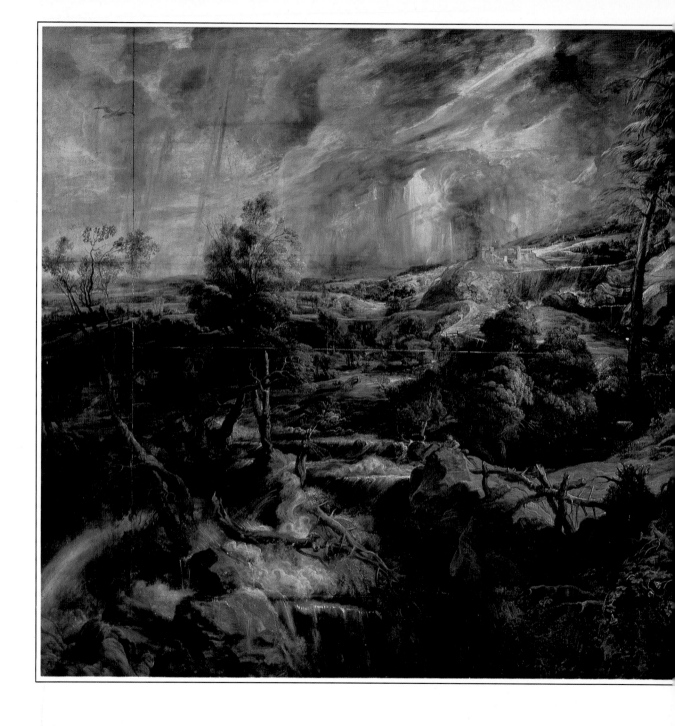

◁ Landscape with Philemon and Baucis c.1636-40

Oil

IN THIS, Rubens' second treatment of the classical story of Philemon and his wife Baucis, an elderly and poor Phrygian couple who once received the gods Zeus and Hermes with great generosity from their meagre resources, he has moved the story on from the actual provision of hospitality, to the point at which Philemon and Baucis are rescued from the Phrygian Deluge, to be deposited on a hill with the gods. This has given Rubens the opportunity to paint a wild, wind-lashed landscape, in which the waters of a great storm have turned a river into a swollen torrent.

The Judgement of Paris c.1638

Oil

▷ *Overleaf pages 76-7*

WHEN THE Cardinal Infant Ferdinand, brother of Philip IV of Spain, made one of several visits to Rubens' studio to check on the progress of the king's great commission for work for his Torre de la Parada summer palace near Madrid – Rubens' last great commission – he noticed this large *Judgement of Paris*, one of several versions of the classical story produced by Rubens. The Cardinal was greatly impressed by the joyous, frankly painted beauty of the life-sized naked goddesses. He was also a little worried, thinking of where the picture was to hang. Should not the goddesses have a little more drapery about them? Fortunately, Rubens was able to persuade him that it was too late to alter the painting, and it was sent off to Spain as it was. Philip IV was delighted with it.

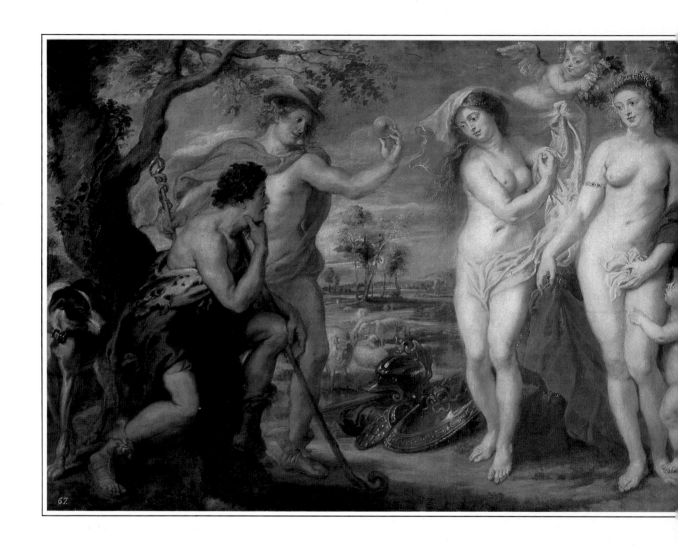

67.

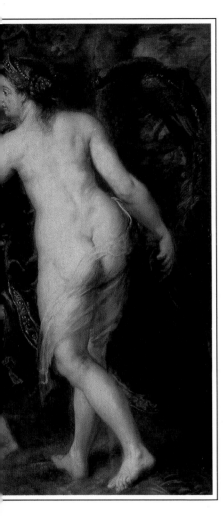

▷ **Self-portrait** c.1639

Oil on canvas

IN THIS self-portrait Rubens
has taken clear-eyed note of
the physical changes in himself
in recent years. He has
portrayed a distinguished
gentleman, hand on sword
and staring, keen-eyed still,
out of the canvas. But there is
more than a hint of tiredness
about the eyes, and it is
possible that the glove on the
right hand hides the effects of
gout. This was Rubens' last
self-portrait, probably painted
less than a year before his
death.

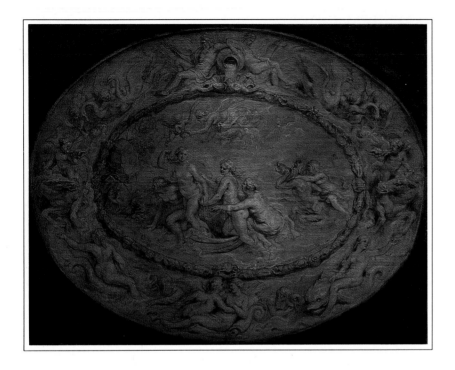

△ **The Birth of Venus** 1632-4

Chalk and grisaille on wood

THIS EXQUISITE drawing, a modello probably for a silver bowl, well illustrates Ruben's many-sided genius. There is great inventiveness in the composition of this drawing, which flows perfectly round the oval, and in the balanced way in which the central figures become part of the total composition, with everything working, perfectly balanced, together. The central group of figures, all of them exquisitely drawn, is dominated by the figure of Venus stepping out of her shell onto the island of Cyprus. Above her, at the top of the oval, are Neptune and Amphitrite, and below are Cupid and Psyche.

ACKNOWLEDGEMENTS

The publisher would like to thank the following for their kind permission to reproduce the paintings in this book:

Bridgeman Art Library, London/Prado, Madrid: 9, 10, 13, 16-17, 52, 58-59, 68-69, 72, 76-77; /**Christie's, London**: 11, 28-29, 34-35; /**Staatliche Kunstsammlungen, Dresden**: 14-15; /**Alte Pinakothek, Munich**: 18, 31; /**Alte Pinakothek, Munich/Giraudon**: 70; /**Onze Lieve Vrouwkerk, Antwerp Cathedral**: 19; /**Hermitage, St. Petersburg**: 20 (*also used on front cover, back cover detail and half-title page detail*), 62; /**Courtauld Institute Galleries, University of London**: 21, 65; /**Wallace Collection, London**: 23, 26, 53; /**Gemaldegalerie, Kassel**: 24-25; /**Private Collection**: 10, 49; /**Dulwich Picture Gallery, London**: 32-33; /**Mauritshuis, The Hague**: 36-37; /**Louvre, Paris/Giraudon**: 38, 39, 40-41, 42-43, 45, 60-61, 71; /**Louvre, Paris**: 57; /**National Gallery, London**: 46, 51, 64-65, 66-67, 69, 78; /**Galleria degli Uffizi, Florence**: 47, 48, 54; /**Whitehall, London**: 55; /**Kunsthistorisches Museum, Vienna**: 74-75, 77

NB: Numbers shown in italics indicate a picture detail.

Every effort has been made to trace the copyright holders and we apologise in advance for any unintentional omissions. We would be pleased to insert the appropriate acknowledgement in any subsequent edition of this publication.